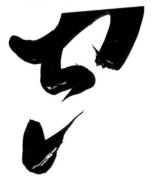

IN LOVE
WITH THE WAY

CHINESE POEMS OF THE
TANG DYNASTY

EDITED BY
FRANÇOIS CHENG
CALLIGRAPHY BY
FABIENNE VERDIER

SHAMBHALA
Boston & London
2002

SHAMBHALA PUBLICATIONS, INC.
Horticultural Hall
300 Massachusetts Avenue
Boston, Massachusetts 02115
www.shambhala.com

©2001 Albin Michel
Translation ©2002 Shambhala Publications, Inc.

Collection directed by Jean Mouttapa and Valérie Menanteau
Photography by Sylvie Durand
Layout Design by Céline Julien

9 8 7 6 5 4 3 2 1

First Shambhala Edition
Printed in France

⊗ This edition is printed on acid-free paper that meets the American
National Standards Institute Z39.48 Standard.

Distributed in the United States by Random House, Inc.,
and in Canada by Random House of Canada Ltd

LIBRARY OF CONGRESS CATALOGING-IN-PUBLICATION DATA

Poesie Chinoise.
 In love with the way: Chinese poem of the Tang Dynasty/
 edited by François Cheng; calligraphy by Fabienne Verdier.
 p.cm. — (Shambhala Calligraphy)
 ISBN 1 57062-979-X
 1. Chinese poetry—Ta'ng dynasty, 618-907—Translations
into English. I. Title: Chinese poems of the Tang Dynasty.
II. Cheng François, 1929 – III. Title. IV. Series.

PL2658.E3 P636 2002
895.1'1308—dc21 2002017667

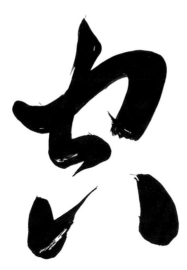

THE POEMS PRESENTED HERE represent the essential part of a written heritage that I know by heart. Excerpted from my work, *Entre source et nuage* (*Between Spring and Cloud*), they exemplify a poetic tradition whose richness is inexhaustible. This tradition, which dates from the Tang dynasty (618–907), corresponds to the golden age of Chinese classical poetry. Poets at that time were able to perpetuate, by building on it further, a literary culture whose origin goes back nearly a thousand years before our era. For about four centuries, thanks to a coming together of circumstances that were favorable on all levels—political, economic, and cultural—as though fulfilling a sacred mission, they took poetic creation to a level of intensity and accomplishment that has never been reached again since. It reached a point where poetry, in association with calligraphy and

painting—known in China as the Triple Excellence—became the expression of the highest spirituality. We know that this spirituality was nourished by three currents of thought: Taoism, Confucianism, and Buddhism. At one and the same time opposed and complementary, ceaselessly intermingling, these three religions contributed to the enrichment of Chinese thought by endowing it with a multiple viewpoint, and by preventing it from remaining one-dimensional and fixed. In its own way, poetry participated in this movement of a body of thought that was in a continual process of internal transformation.

In the Tang period, China recovered its unity after the collapse of the first empires (the Qin and the Han) and the long period of disorder and division resulting from barbarian invasions. At that point the three currents of thought, now recognized as the ideological foundation of society, came to pervade the realm of artistic creation. In the domain of poetry, three representative figures stand out. Li Po, who was inclined toward Taoism and in love with freedom, sings of total communion with nature and with beings. Du Fu, who was essentially Confucian, gave voice primarily to humanity's painful destiny, but also its greatness. Wang Wei, an adept of Ch'an Buddhism toward the end of his life, captures his meditative experiences in verses of perfect simplicity. Beside these giants, there are a great number of other poets who were their contemporaries or who came one or two generations after them. Each in his own way exalts the themes

dear to him: Meng Haoran and Jia Dao reveal in spare, unadorned verses, their desire for escape and spontaneous communication. Bo Juyi denounces social injustice and describes the suffering of humble folk while harking back to the form of ancient popular song. Li Shangyin makes himself the ardent singer of passion and love. Qian Qi discovers the poetic rhythm that animates nature from the inside. Du Mu, at the end of the Tang period, expresses the fullness of nostalgia felt for happiness experienced or dreamed. Wei Yingyu is one of the major figures of the generation immediately following that of the great poets of the "prosperous Tang." Li Yu, the last emperor of the Southern Tang dynasty, helped to bring new life to the language of poetry.

What is the future fate of Chinese poetry? No doubt it will have to reinvent itself once again. Its path to salvation is one that passes through ever new metamorphoses, which could never come about without profound encounters with other poetic traditions and other artistic traditions, such as that of calligraphy. Poetry is the search for communion. The road its development takes, while always remaining one, has divisions and forks all along the way.

François Cheng

TO A FRIEND WHO ASKS ME QUESTIONS

Why do I live at the heart
 of these green mountains?
I smile without replying,
 my **mind** wholely serene.
Flowers fall, water flows,
 mysterious way . . .
It's the other world that's there,
 not that of humans.

Li Po

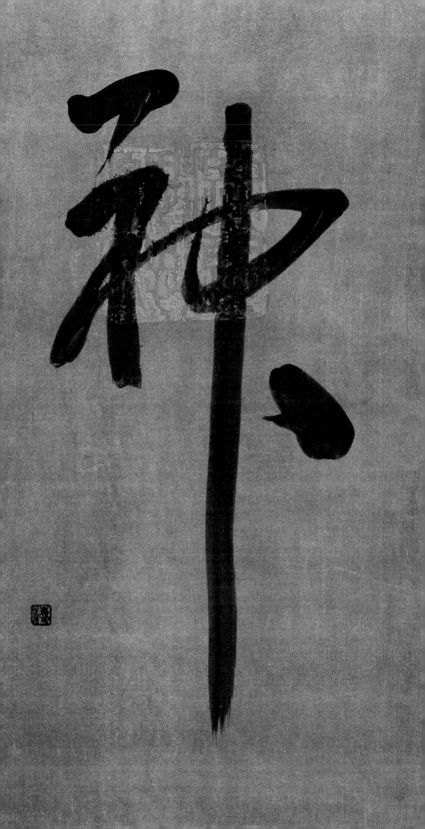

MY REFUGE AT THE FOOT OF ZHONGNAN MOUNTAIN

In the midst of age,
 in love with the Way,
Below Zhongnan
 I have made my dwelling.
When the desire takes me,
 I go there alone:
Alone, too, in enjoying
 ineffable views. . . .

Walk to the place
 where the spring peters out
And wait, seated,
 for the clouds to come up.
Sometimes, wandering,
 I run into a hermit.
We laugh, we talk,
 without a care about
 getting back.

Wang Wei

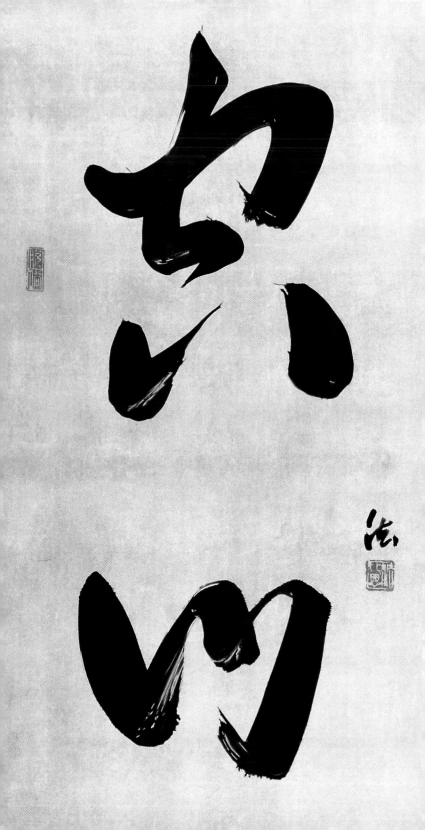

IN THE STAGS' GARDEN

Empty mountain,
 not a soul to be seen.
Only echoes of voices
 sounding in the distance.
Ray of the setting sun
 in the deep woods:
On the moss
 a final burst of light: green.

Wang Wei

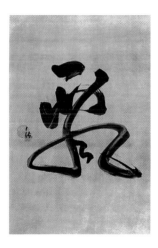

NIGHTTIME NOTES OF
A TRAVELER

Does a man leave a name behind
 just by his writings?
Old, sick,
 let the mandarin step aside!
Wandering, wandering,
 what do I resemble?
A sand gull,
 between heaven and earth.

Du Fu

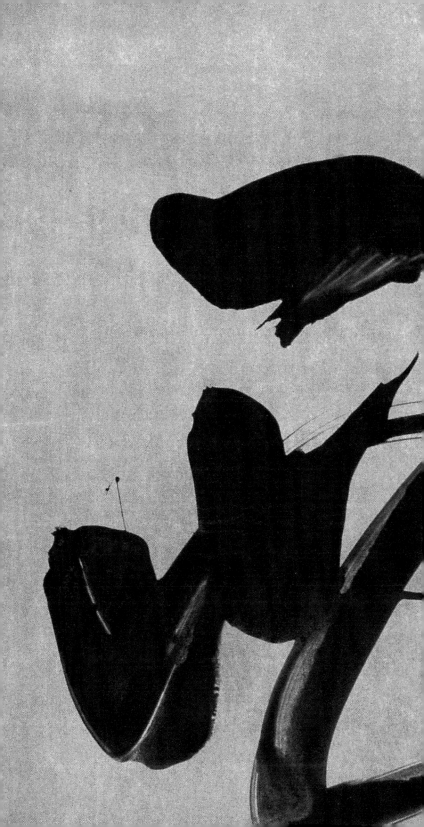

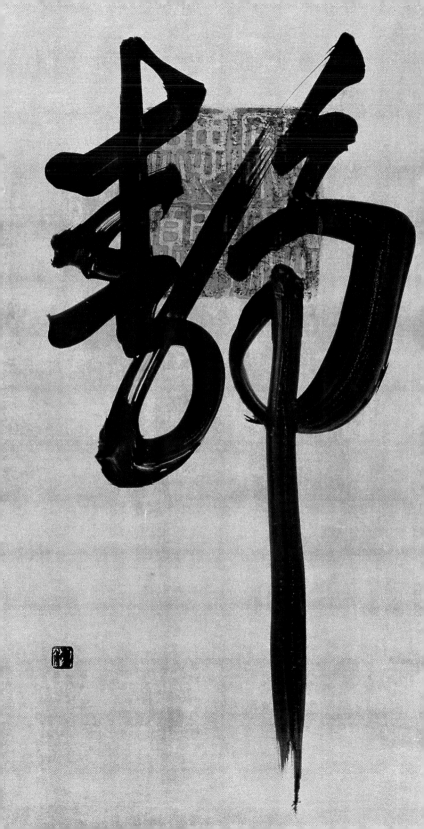

To the Honorable Magistrate Zhang

As of late, all I like
 is **quiet**.
Far from my mind
 the vanity of things.
Stripped of all resources,
 what I have left is the joy
Of hanging around again
 in my old forest.

The breeze in the pines
 undoes my sash;
The moon caresses the sounds
 of my dulcimer.
What is, you ask,
 the ultimate truth?
Song of the fisherman
 in the reeds, fading into the distance. . . .

Wang Wei

To the Air of "Mulan Hua"

Copper reed vibrating
 in the hollow of the bamboo
Jade hand caressing
 the slow melody
There where glances meet
 waves of autumn flood space

Raincloud suddenly rents
 the embroidered walls
Furtive meeting
 desires granted
The feast over
 emptiness asserts itself once more
Souls dissolved in the dream
 seek each other without end

Li Yü

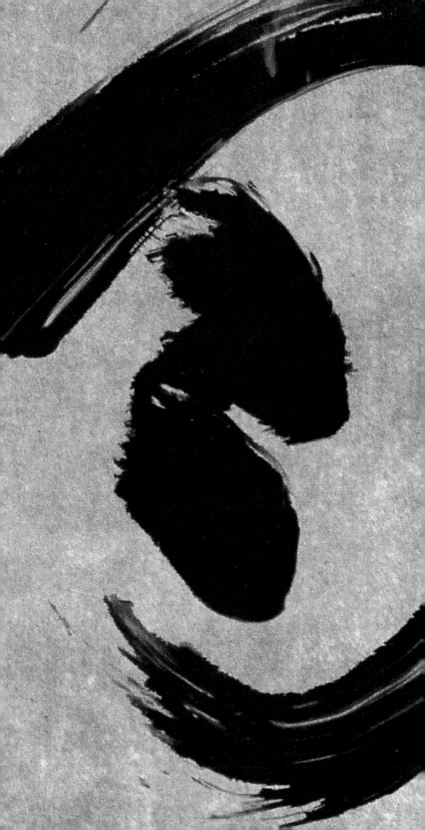

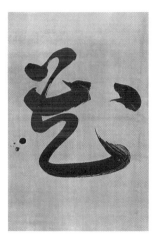

Neither Flower nor Mist

Flower. Is it a flower?
Mist. Is it mist?
Arriving at midnight,
Leaving before dawn.
She is there: sweetness
 of an ephemeral spring.
She has gone:
 morning cloud, not a trace.

Bo Juyi

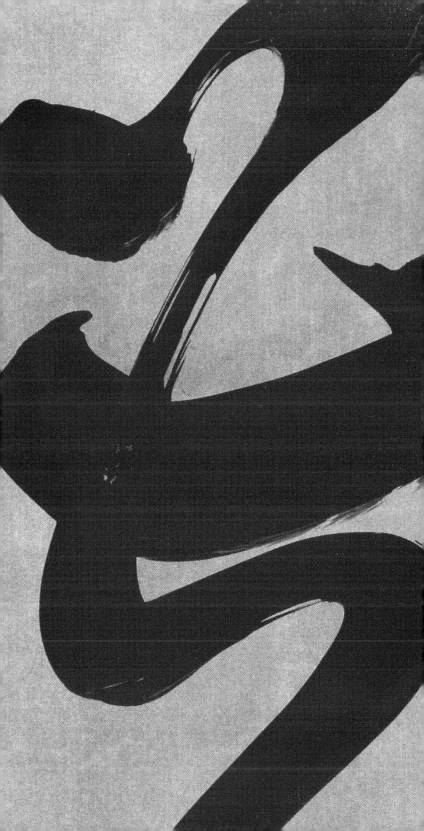

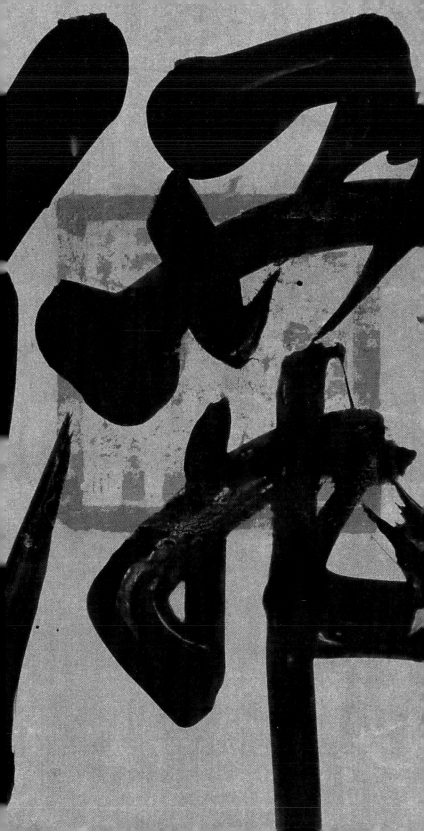

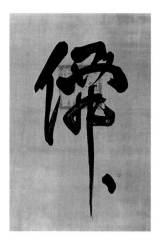

POEM TO ACCOMPANY TIAN ZHUO WHO IS GOING TO LIVE AT MOUNT HUA

When a stork passes,
 follow it with your eyes:
She's carrying on her back—
 do not doubt it—an **Immortal**.

Jia Dao

Night Thought

Before my bed bright moonlight,
Is it frost covering the ground?
Head lifted, **I look at the moon**;
Eyes lowered, I think of my native soil.

Li Po

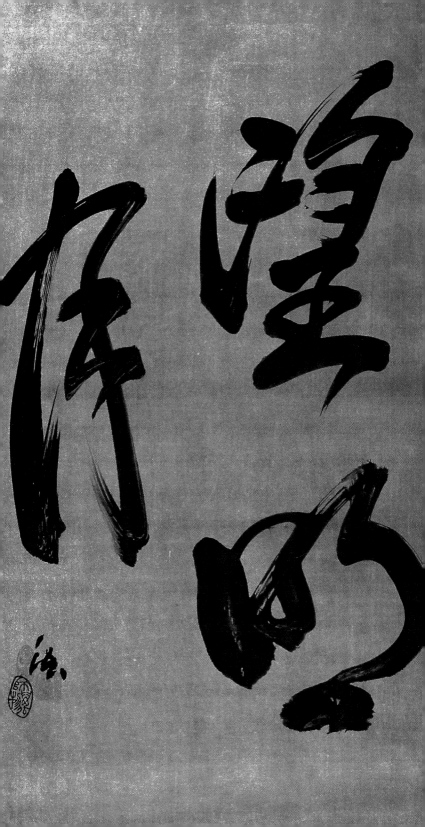

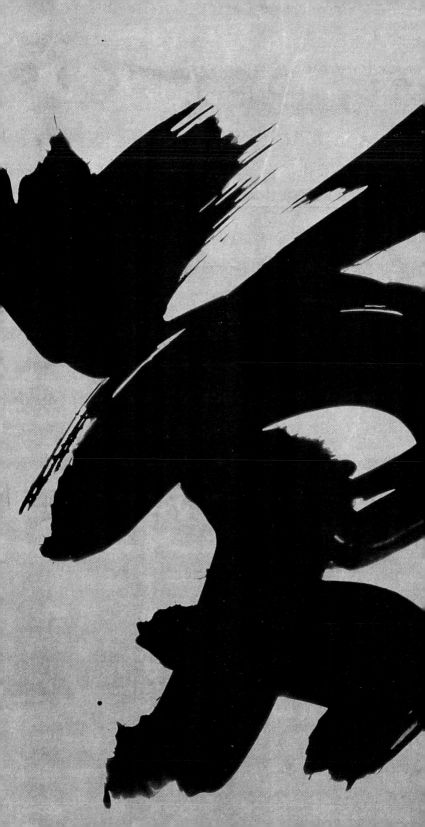

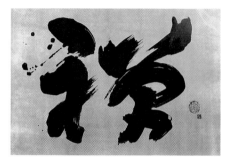

YI GONG'S CELL IN THE TEMPLE OF DAYÜ

Master Yi, practicing **Ch'an mind**
In his dwelling place on a wooded mountain.
Shutters open: the high peak leaps;
Before the threshold, the valleys roll.

Meng Haoran
FIRST QUATRAIN

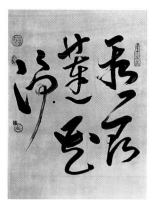

Yi Gong's Cell
in the Temple of Dayü

At the hour of dusk, wreathed in rain,
Green shadow spreads over the court.
Embrace the purity of the lotus:
Its soul untainted by the mud.

Meng Haoran
SECOND QUATRAIN

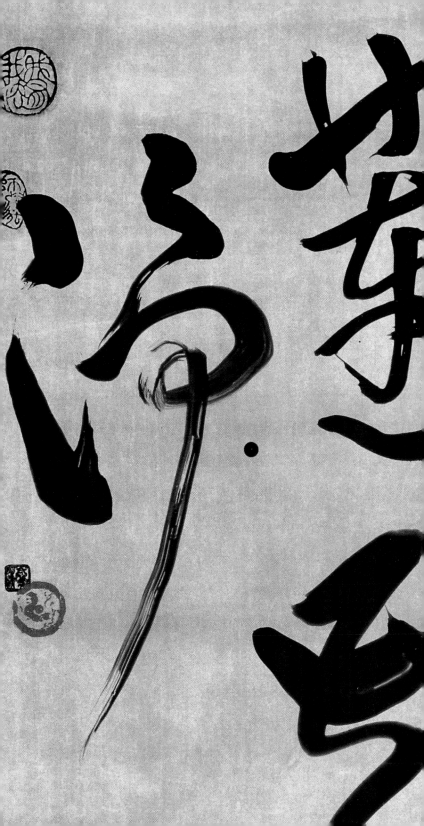

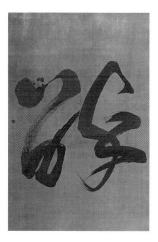

DRINKING ALONE UNDER THE MOON

Jug of wine amongst the flowers.
Drinking alone, without a companion.
Raising my cup, I toast the moon:
With my shadow, that makes three of us.
But the moon doesn't know how to drink.
It is futile for the shadow to follow me.
Nonetheless, let us honor shadow and moon:
Real joy only lasts for a springtime!
I sing and the moon fiddles around.
I dance and my shadow plays games.
Aroused, we take pleasure in one another;
And **drunk**, each one goes his own way.
Reunion on the Milky Way:
Tramping along forever without a care!

Li Po

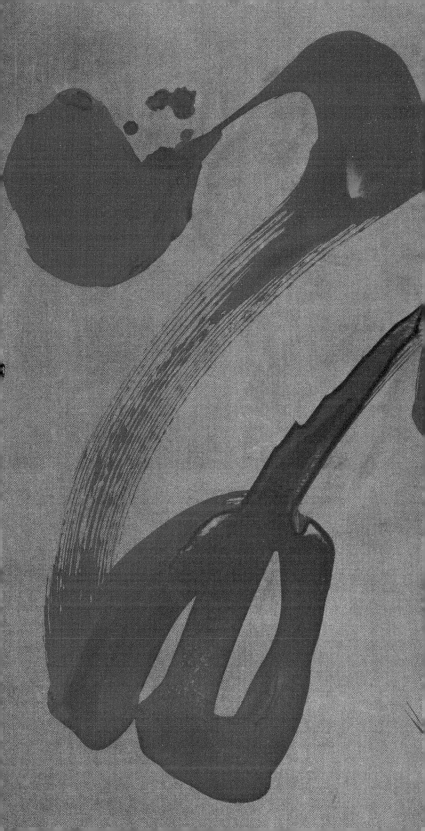

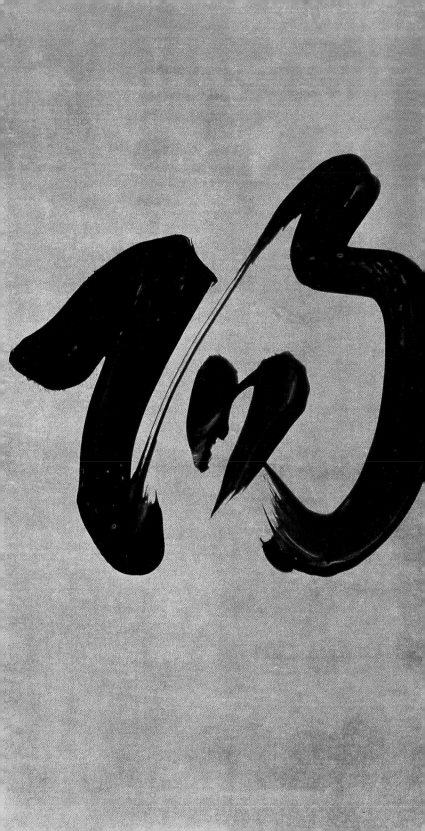

ZHONGNAN MOUNTAIN

Crest supreme,
 close to the Celestial City,
From mountain to mountain
 extending to the sea.
When contemplated, the white clouds
 add up to no more than one;
When pierced, the green rays
 suddenly fade out.

Crowned with heavenly bodies,
 the central peak turns;
Encompassing **yin and yang**,
 the valleys roll.
Go down and find
 shelter for the night:
Above the stream there,
 let's have a chat with the woodcutter.

Wang Wei

Dedicated to the Hermit Cui

Path of herbs,
 carpet of red moss,
Window in the mountains,
 brimming with greenery....
I envy your wine
 in the midst of the flowers:
Those butterflies that flutter
 in your **dream**.

Qian Qi

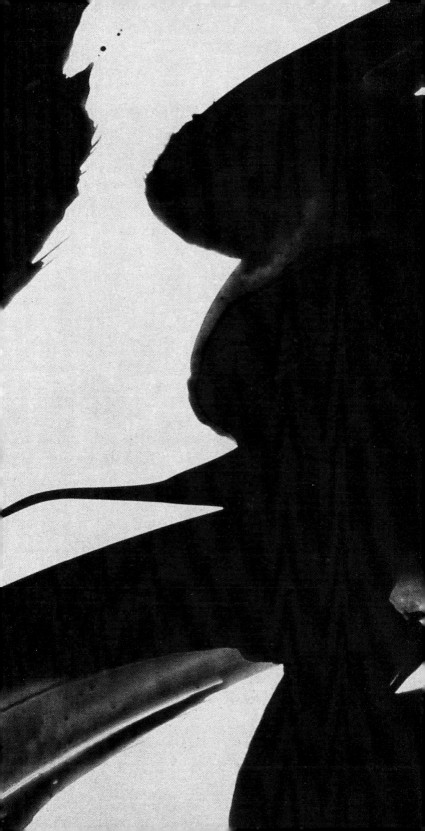

At the House of an Old Friend

My old friend invites me
 to his country place
Where chicken and millet
 are already prepared.
Rows of trees
 walling in the village;
Beyond the ramparts,
 the **blue mountain** bows.

Meng Haoran

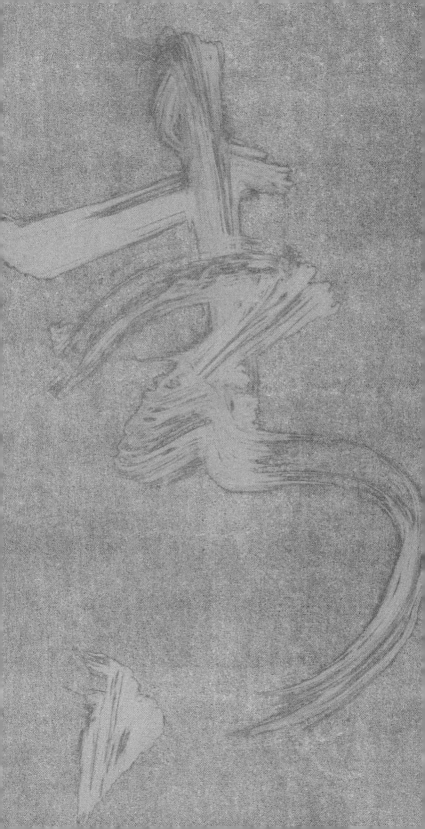

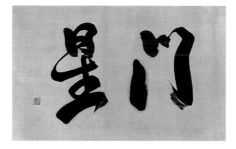

SUMMIT TEMPLE

Summit Temple, at night:
Lift your hand and **caress the stars**.
But shhhh! Lower your voice:
Let's not wake the sky people.

Li Po

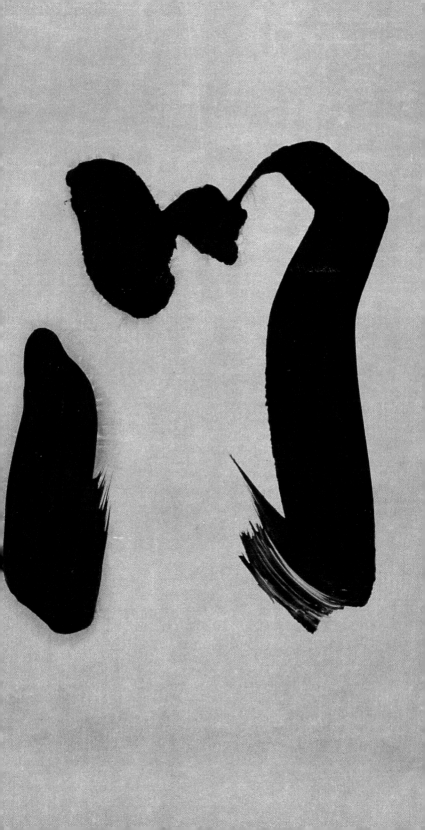

獨坐幽篁裏彈琴復長嘯

In the Bamboo Pavilion

Sitting alone in the midst of the bamboos,
I play the lute and whistle along;
Forgotten by everyone, deep in the woods.
The moon came hither: brilliance!

Wang Wei

ALONE ENJOYING THE BLOSSOMING OF FLOWERS ON THE RIVERBANK

On the banks of the river,
 miracle of flowers without end.
But who can I share this with?
 It's enough to drive one **mad!**
I go to the house of my neighbor,
 my companion in wine:
He's gone drinking,
 ten days already, his bed empty. . . .

Not that I love flowers
 to the point of dying
What I'm afraid of: beauty faded,
 old age at the door!
Branches overloaded,
 flowers fall in bunches.
Tender buds come to an agreement
 and open sweetly.

Du Fu

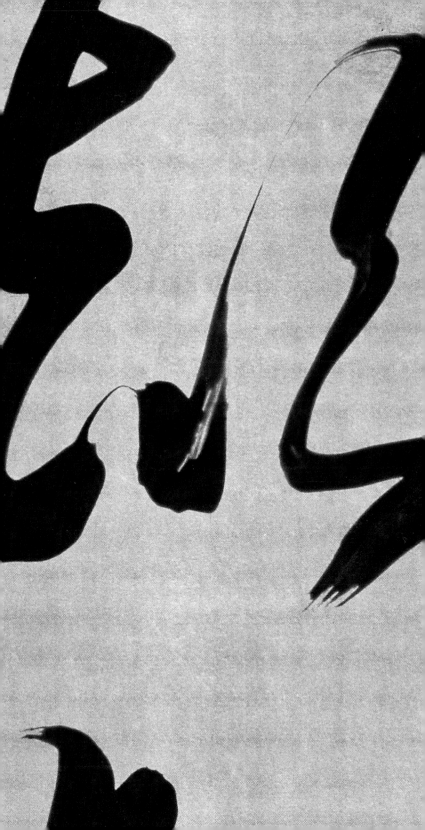

Poem of Farewell

A great **passion**
 resembles indifference:
In front of the mute cup
 no smile comes to one's lips.
It's the candle that burns
 with the pangs of farewell:
Right up to dawn, on our behalf,
 it sheds tears.

Du Mu

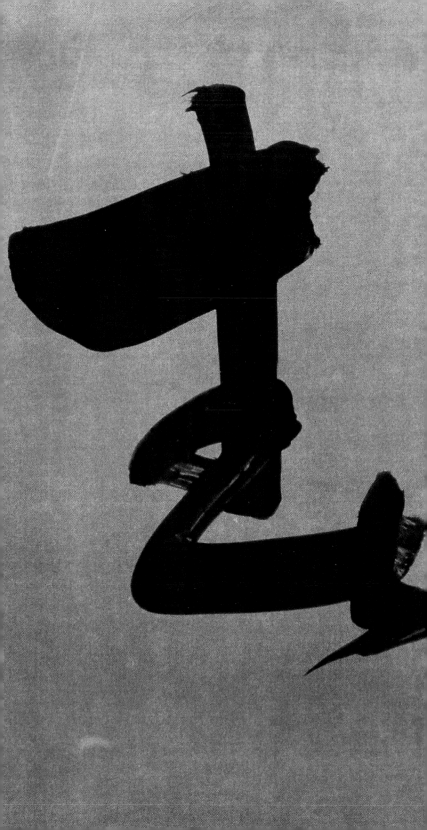

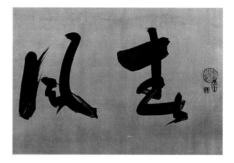

GRASSES OF THE ANCIENT PLAIN

Tender grasses across the plain
Every year wither and grow back.
The wildfires fail to put an end to them,
With the breath of spring, they are reborn.

With their fragrances, they perfume the ancient way,
Emerald sheaves in the ancient ruins.
Agitated and quivering with nostalgia,
They bid farewell to the departing lord.

Bo Juyi

The Plateau of Leyou

In the evening,
 suffocating with melancholy,
In my coach
 on the ancient plateau.
Rays of the setting sun
 infinitely gentle:
Too brief, alas,
 this close to nightfall.

Li Shangyin

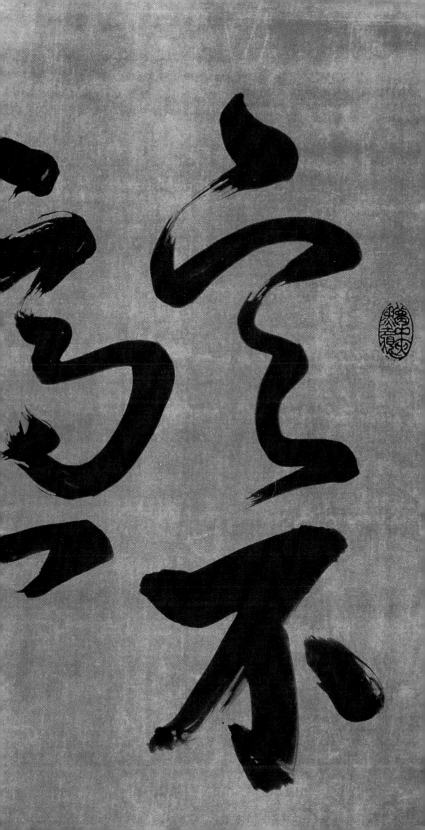

Visiting a Hermit and Not Finding Him

Under the fir tree, I question the disciple.
"The master has gone to gather herbs.
Over there, at the foot of this mountain."
Thick clouds: no idea where. . . .

Jia Dao

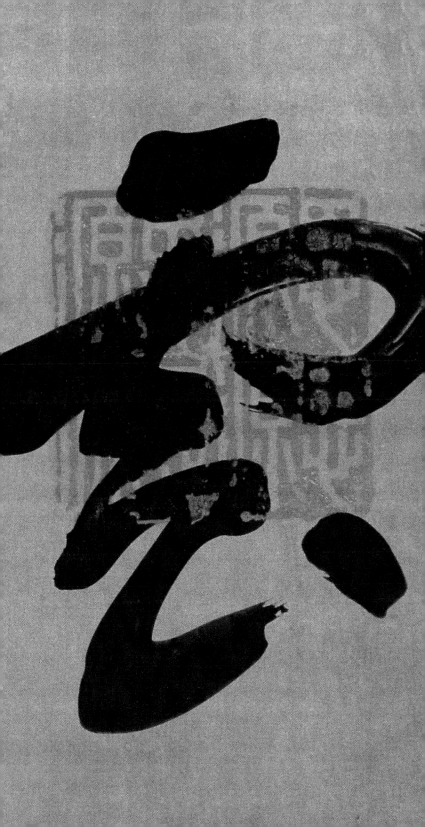

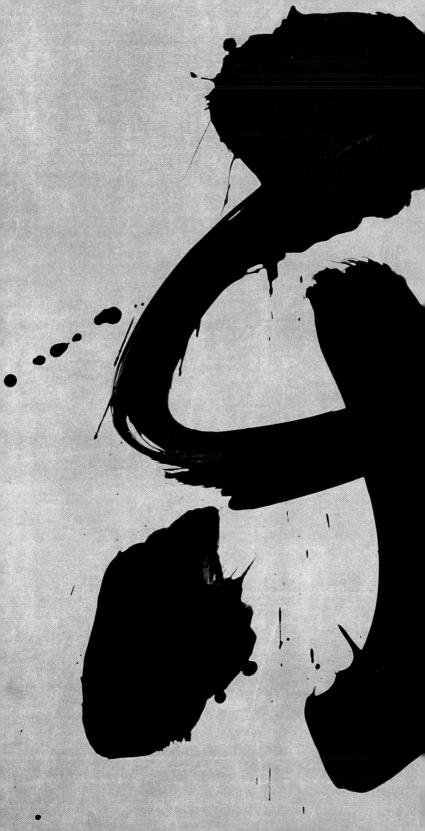

On Copper Mandarin Mountain

Copper Mandarin,
 high place of my **joy**.
A thousand years I would stay
 without a shadow of regret.

I dance at my whim:
 my floating sleeve
Brushes with one sweep
 all the pines on the mountaintops!

Li Po

On Mount Langya

At Rocky Portal,
 not a track in the snow;
Only the incense still mingles
 with the valley mists.
Leftovers of a meal in the courtyard:
 a bird floats down.
Rags caught on the pine:
 the old bonze is dead.

Wei Wangyu

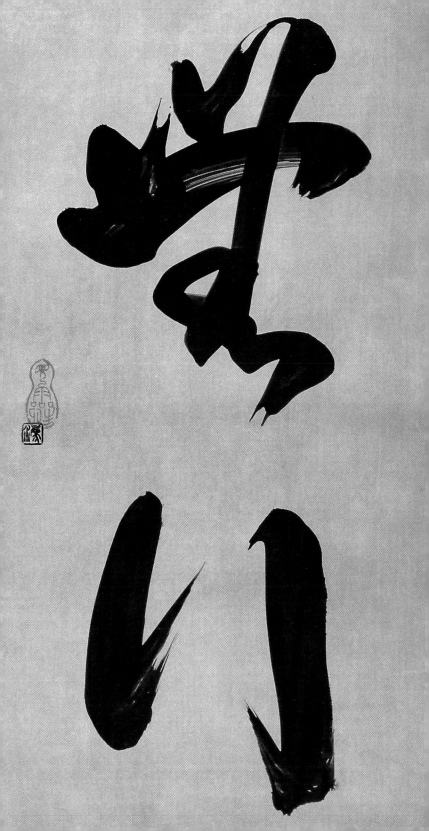

FABIENNE VERDIER

"To have the experience of immediacy
is the supreme excellence."

Heraclitus

IT WAS IN 1983 that I left for China, in search of Orien-
tal wisdom. I had decided to continue my studies of aes-
thetics and painting there. I sensed that in that culture, of
which so little is taught in the West, I would be in a bet-
ter position to get in touch with the "creative process,"
the secret of the thousand transformations of the art of
the brush. By penetrating the mystery of the intelligence
of the brush stroke, I would enrich my inner experience
as a painter, and perhaps one day, in my turn, become a
master of this subtle knowledge. Thus I set off in search
of a master who would open his door to me, who would
accept me as an apprentice.

My meeting with Master Huang Yuan and the long

years of apprenticeship spent at his side remain anchored in my memory as one of the richest times of my life's journey. With him I understood that calligraphy was in truth an art of living, an austere one to be sure, but how very rich and fruitful! Learning silence, detaching oneself from the affairs of the world, keeping to the contemplative life, entering into resonance with the seasons, the gusts of winter wind, the sacred mountains, being one with the countryside, observing the movement of the stars, the formation of clouds, the structure of plants, the nature of a cricket's call, summer on the doorstep.... Like a human being the world breathes, and a calligrapher must have his heart open so as to breathe into his stroke the pulse of the universe. For that, he must try to cultivate receptivity, discover wholeness, be attuned to his emotions and his inner being. Such are the rules of this ancestral wisdom that were transmitted to me by my aged master, even before he taught me the art of the brush.

Among the variety of styles that exist in the art of Chinese calligraphy, there is one that I find particularly compelling. One day, Zhang Xu, a great master of the Tang dynasty with the nickname "the madman of calligraphy,"

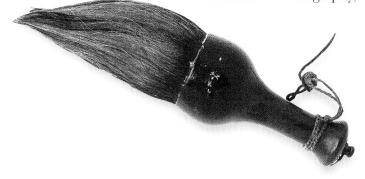

was observing the composition of dried herbs. They seemed to him to be so beautiful in the vigor of their lines that they inspired him to invent a style of writing called "crazy grass." In this way he became the "supreme master of the cursive style." This was a revelation for me. It was only after many years of apprenticeship that I turned my attention to this technique. Its captivating freedom, its expression of purity, its unpredictable beauty, its total spontaneity, its surprising subjectivity, its lightninglike way of interpreting poetic thoughts—all this appeared to me to correspond to my vision of the world.

With humility and patience, I began to study this style of writing, its history, its internal structure, with two aims: to work the ink, which is a part of the world of matter, and to work the vital breath that is part of the world of the extraordinary. Rigor was required in practice and boldness in invention in order to learn the maddest of paradoxes: action and non-action, light and dark, full and empty.

I made hundreds and hundreds of strokes in an attempt to approach this ultimate beauty. For that it was necessary for me to go back to the root of things. What an incredible discovery it was for me, a Westerner, finding that I had the intuition to touch the miraculous. Finally I understood what it means to paint without making a mark. In this way the creative essence of calligraphy opened up for me

the paths of painting. My brush in my hand, my gaze on emptiness, I suddenly understood that nothing should remain in a picture but the spirit of form, and not real, interpreted form. At that point I discovered a path that perhaps would permit me to grasp the quintessence of beings, of thoughts, to capture, with the stroke of a brush, the beauty of transitory and fleeting emotions.

The calligrapher is a nomad, a passenger in the world of silence. He loves to wander intuitively over boundless territories. He takes one position, then another; he is an explorer in the universe of movement in space-time. He is animated by the desire to give a little taste of eternity to the ephemeral. This is what I would like to share.

The atmosphere of my studio, the presence of my tools and the objects I use in my work draw me into a universe where I breathe calmness. For a few hours, I let daily life fall away and take refuge in this hermitage, which is conducive to meditation. In my dream stone, which I brought back from China, I contemplate the natural mineral designs; I see landscapes in them, limpid springs, mountains in the process of forming, morning mists. At times when inspiration comes hard, these help me to nourish myself, to restructure my inner space, to enliven my imagination. In the old days, the Chinese scholars possessed such a dream stone, which accompanied them on the path of creation.

My inkstone, which is made from rock from the cave of Xia Yan, is an instrument indispensable to a calligrapher's ritual. Just the steady movement of grinding a little ink on its back is enough to let the alchemy of pine, musk, and camphor become the mineral dust that for calligraphers is the key to the dream. . . .

The brushes, made of various materials—hair of rat, fox, wolf, grey goat, boar, sable, marmot, or sheep, but also horse's mane, cock or duck feather—permit me to express on the canvas infinite transformations. They measure the force of movement, of inspired momentum, and instinctively transmit the ebb and flow of the vital breath.

The seals, generally made of soapstone, a soft stone suitable for carving, stay with a painter through his whole life. They provide information to those who understand them about his attitude toward life and about his spiritual universe. Some seals only hold transcriptions of the name or first name of the painter. Positioning the seals to finish off the composition of each work necessitates extreme attention. They indicate the way in which the viewer's mind will perceive the picture. They are the key that permits the viewer to enter the picture. For long moments, indeed sometimes for several days, I linger in front of my page before determining the spot

where these imprints should be placed in order to seal the calligraphy. The cinnabar will enter in and structure the emptiness, complete the delimitation of the space and give harmony to the whole.

Whether we are speaking of the ancient Chinese sages, or of the artists of India, or medieval Europe, the vision of art is not transmitted by a "gift" or mere "virtuosity." There is a method is all this: that of concentration. As for me, the tea ceremony brings me a feeling of tranquillity. It is only at such a moment that I find the inner calm I need finally to get down to work.

The very admirable verses of the ancient Chinese poets, whether they were Taoists, Buddhists, or Confucians, resonate within me. Giving them a new echo with the help of my brushes and my inks enthralls me. For the present collection, I chose to interpret in calligraphy certain concepts that seem to me to touch upon the very essence of Chinese poetry (these are indicated by boldface in the texts). Thus each calligraphed ideogram represents a poetic thought, spiritual or philosophical, which, depending on its environment, its place in space, is the bearer of multiple resonances: "emptiness," "mind," "the Way," "quiet," "embracing the purity of the lotus," "mountain," "caressing the stars," "wandering," "immortality." . . . In trying to transcribe the beauty of these concepts, I went through my ancient works and studied the substance and architecture of these graphic

expressions through the course of Chinese history.

As Meister Eckhart said, "The carpenter first constructs the house in his mind." It is a universal process. Once I have perceived and taken in the dimension of a concept by looking at many interpretations, I wait for inspiration. I wait for the instant of ripeness of body and mind that will give birth to the calligraphy. At this precise moment, the distance that separates me from external nature disappears; it is as though the dream of total communion with the cosmos comes true.

I seek for an osmosis between the living memory of my colors and the spirit of the thought I intend to calligraph. Thus I developed a technique bringing together the ink of China and the glazes of Flemish painting, arriving in this way at a new transparency and luminosity in my calligraphies. Through the use of the glazes, a deep emotion emerges; the vital breath of the black ink becomes more accessible to passing time and to the resonances of the soul.

"Of the great things that we have among us, the exis-

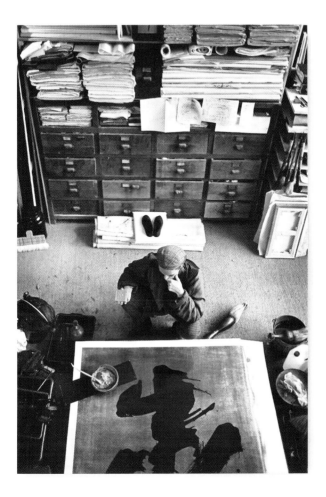

tence of nothingness is the greatest," said Leonardo da Vinci. Becoming aware of nothingness, finding our way in the harmony of emptiness without disrupting its mystery, is that not the greatest of joys?

Fabienne Verdier